PEAKY BLINDERS

OFFICIAL WIT & WISDOM

"I'm not God. Not yet."

— Thomas Shelby

PEAKY BLINDERS

OFFICIAL WIT & WISDOM

WHITE LION PUBLISHING

Thomas Shelby, Esquire is a man of many words; a man of few words. A man of careful planning; a man of action. He's a peaceful man; a violent man. A walking, breathing paradox, Tommy is a family man, a loner, a leader, a politician, a rogue, a liar and a straight shooter. Tommy is all of these – and more.

Here are just some of the many words of wisdom, insight and humour that have been uttered by Tommy and the Shelby family and their many friends (and enemies).

May they inspire, uplift and maybe even help you on your path…wherever it may lead.

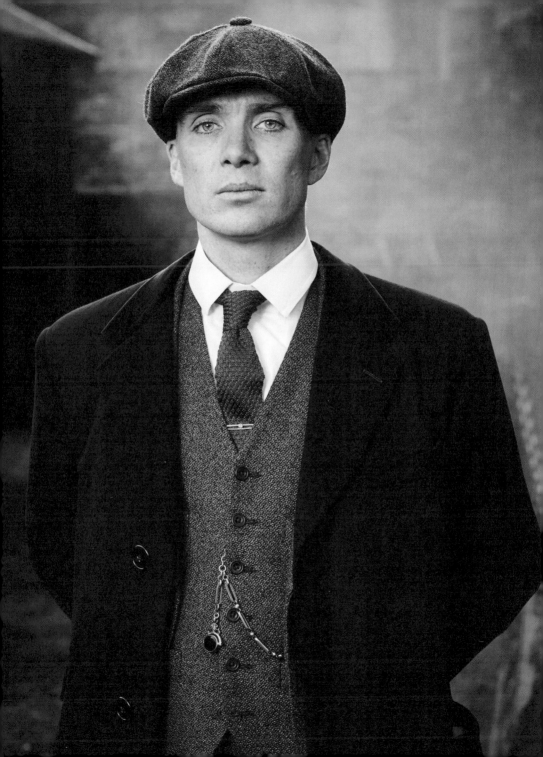

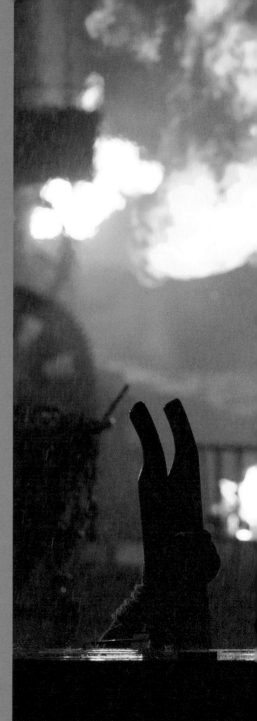

"I don't pay for suits; my suits are on the house or the house burns down."

— Thomas Shelby

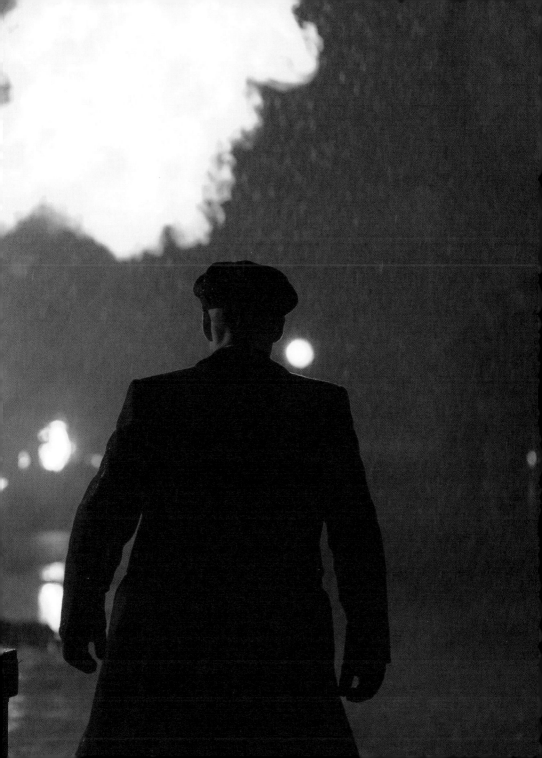

"You don't parley when you're on the back foot."

— Thomas Shelby

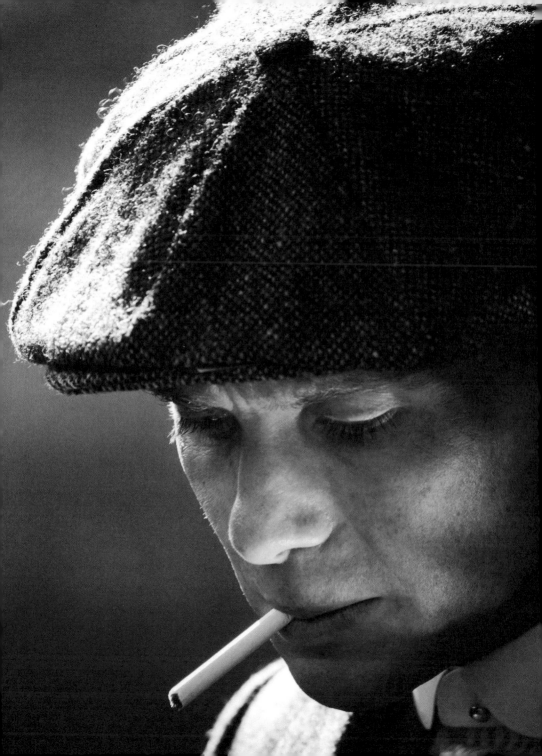

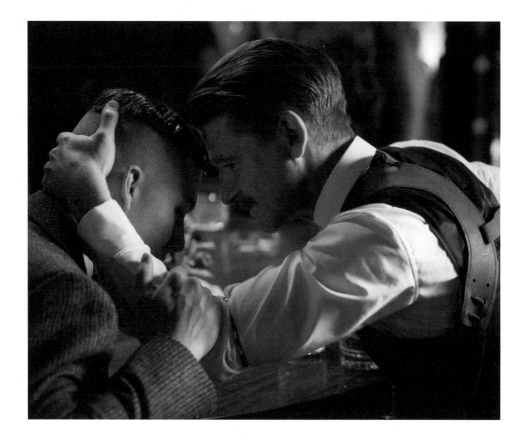

"I've got some trouble that'll keep you out of trouble."

— Arthur Shelby

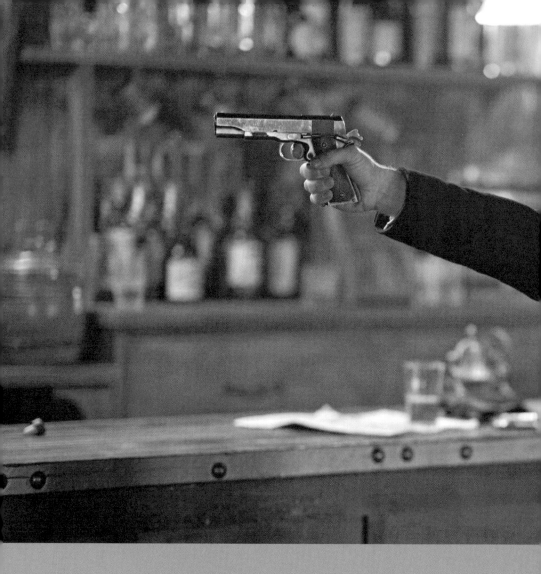

"Since I foreswore alcohol, I've become a

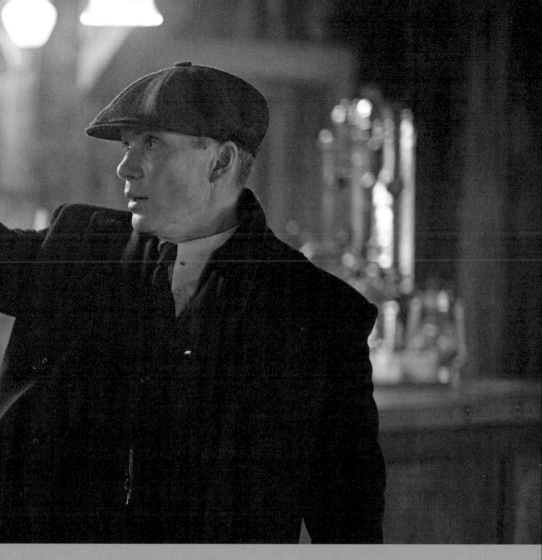

calmer and more peaceful person."
— Thomas Shelby

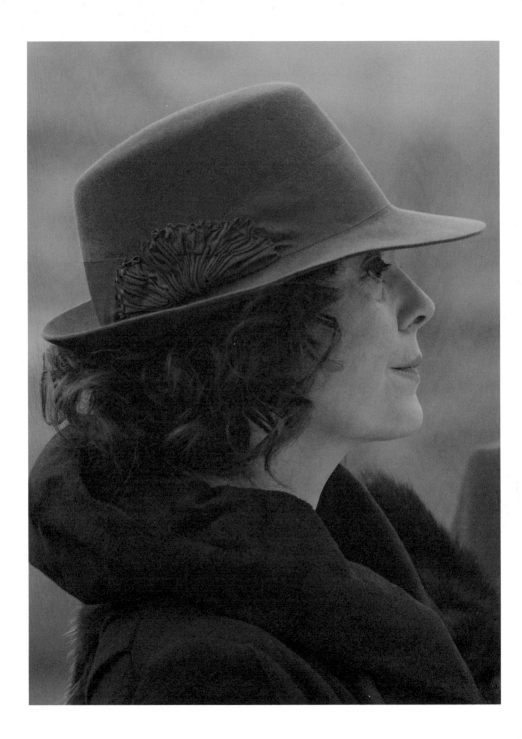

"You have to be as bad as them
above in order to survive."

— Polly Gray

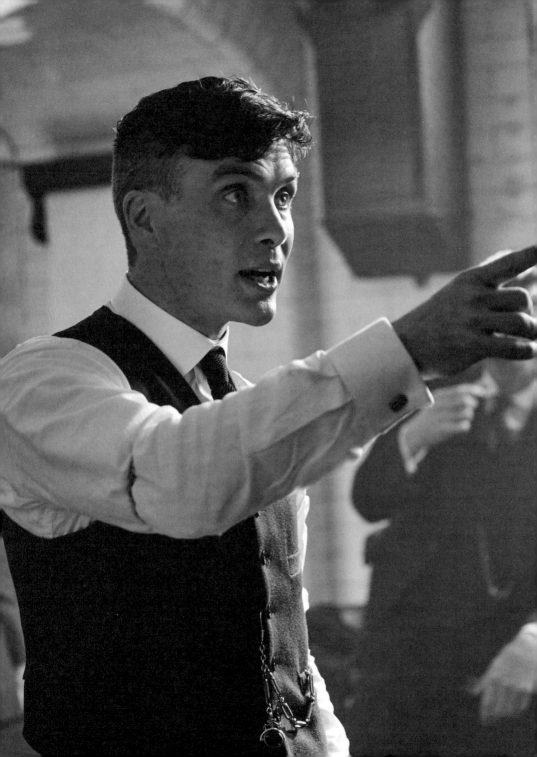

"But the main thing is,
you bunch of fuckers,
despite the provocation
from the cavalry,
no fighting...
No fighting.
No fucking fighting.
No fighting.
NO FUCKING FIGHTING!"

— Thomas Shelby

"For those who make the rules,
there are no rules."

— Thomas Shelby

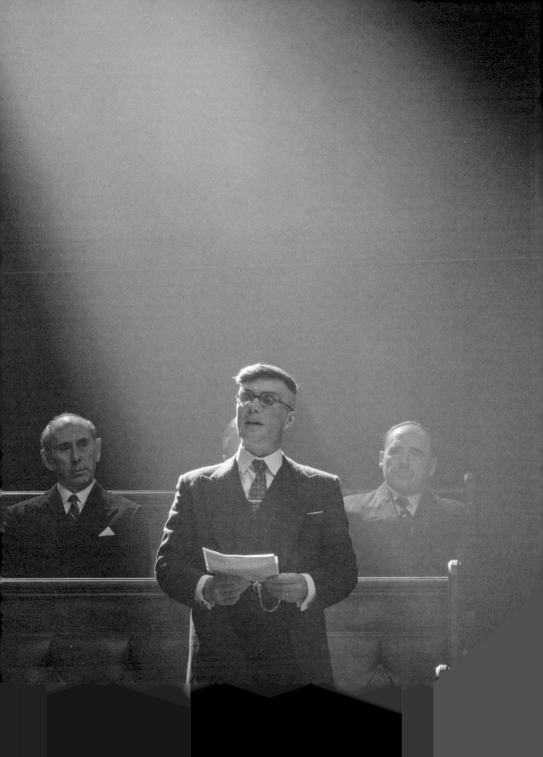

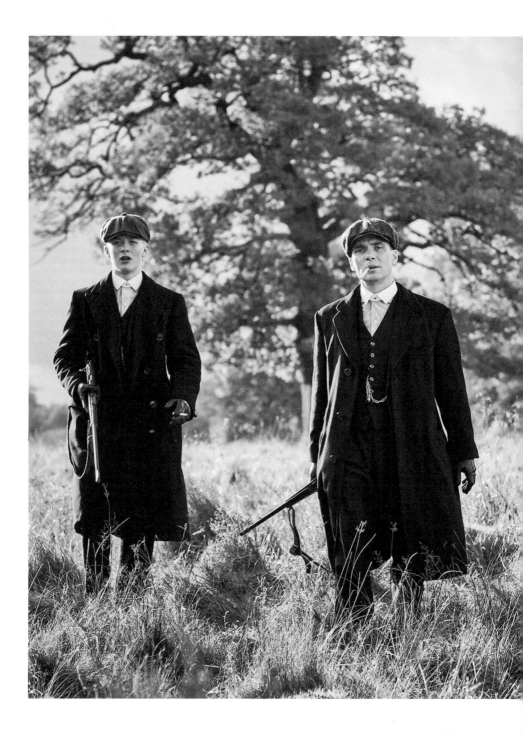

"For me, family is my strength."

— Thomas Shelby

"We're not the Peaky fucking
Blinders unless we're together."

— Michael Gray

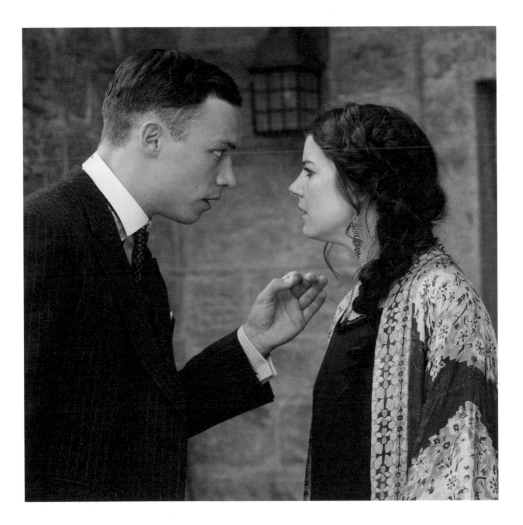

"This place is under new management...

by order of the Peaky Blinders!"

— Arthur Shelby

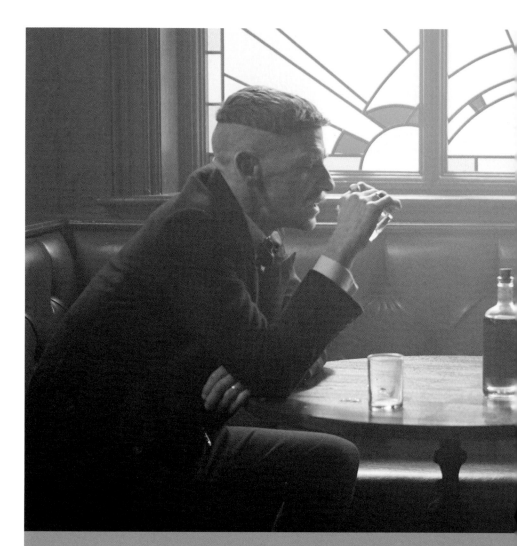

"In pubs sometimes people say things, sometimes it's the whiskey talking.

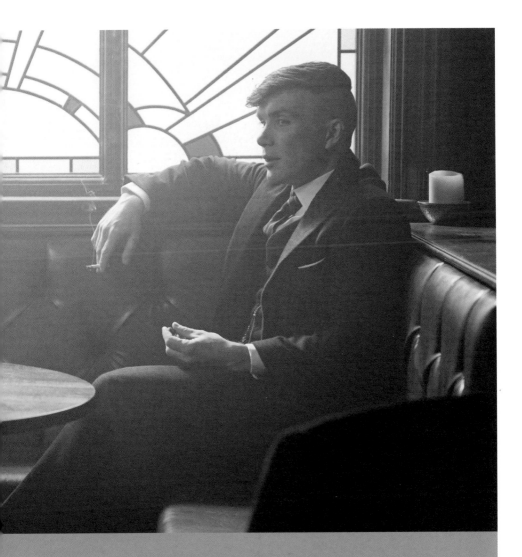

It's hard to tell which is which."

— Thomas Shelby

"You can change what you do, but you can't change what you want."

— Thomas Shelby

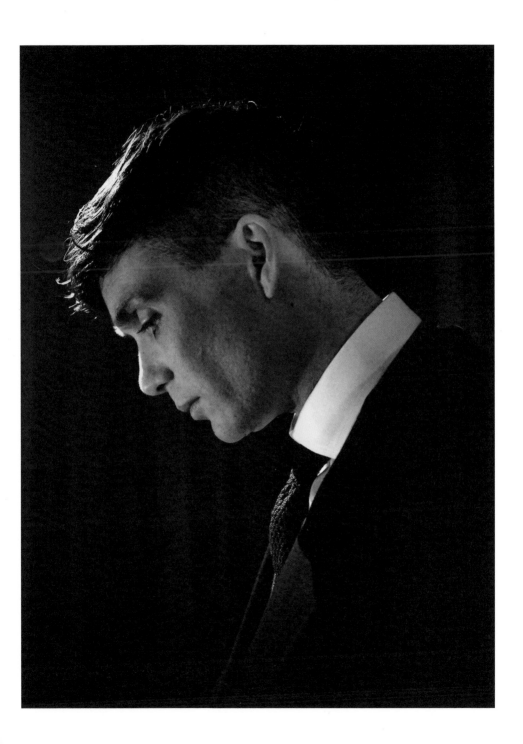

"I do the things
I do so that my
son doesn't have
to do them."

— Polly Gray

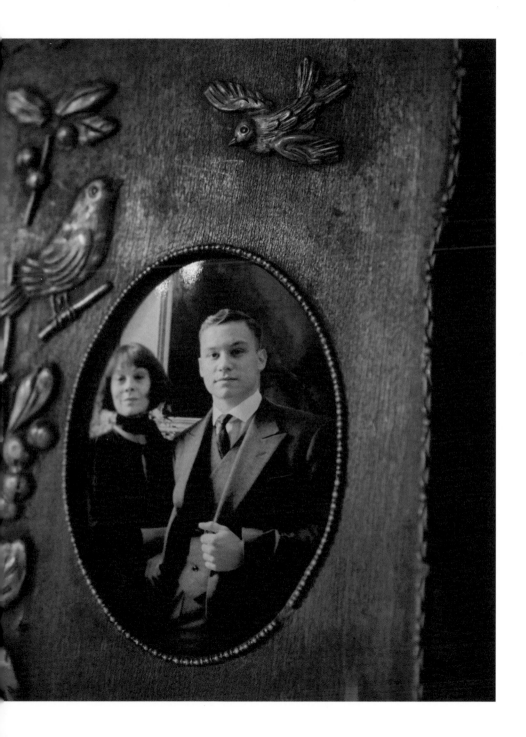

"You have to get
what you want
your own way."

— Thomas Shelby

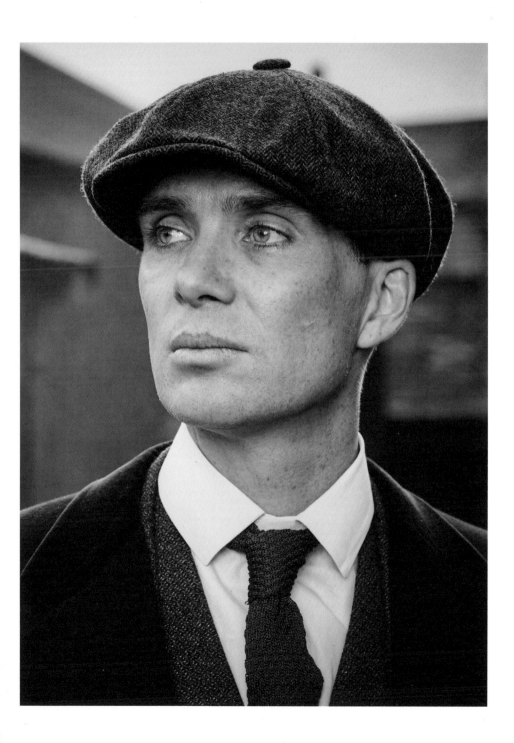

"Distilled for the eradication of seemingly incurable sadness."

— Thomas Shelby

"Do you ever think you've lost your mind, Thomas?" — Esme Shelby

"I lost it long ago. I only use the crate it came in." — Thomas Shelby

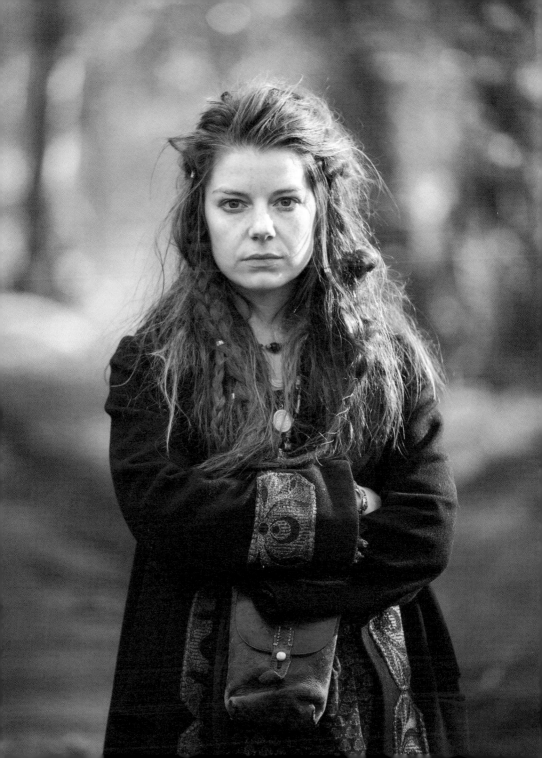

"Whiskey is good
proofing water.
It tells you who's real
and who isn't."

— Thomas Shelby

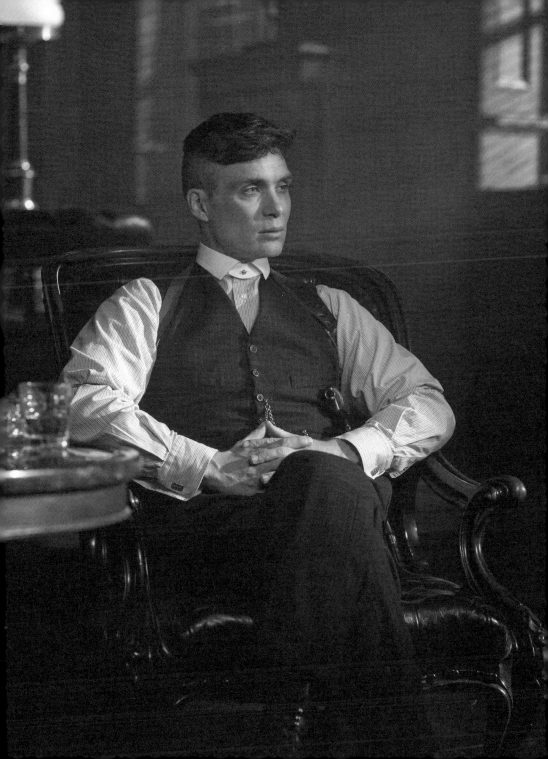

"The men who blew the whistles
in France are our enemy."

— Jessie Eden

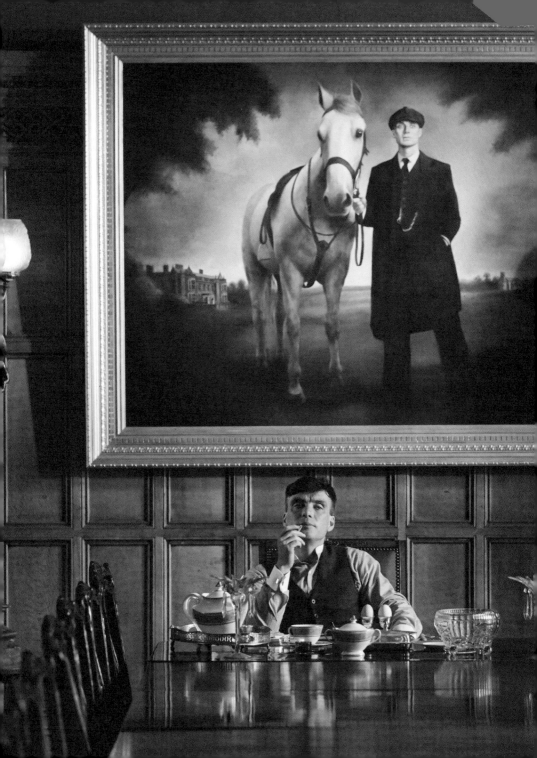

"I'm not a traitor to
my class…
I am just an extreme
example of what a
working-class man
can achieve."

— Thomas Shelby

"If you apologise once, you do it again and again and again. Like taking bricks out of the wall of your fucking house. Do you want to bring the house down, Arthur?"

— Thomas Shelby

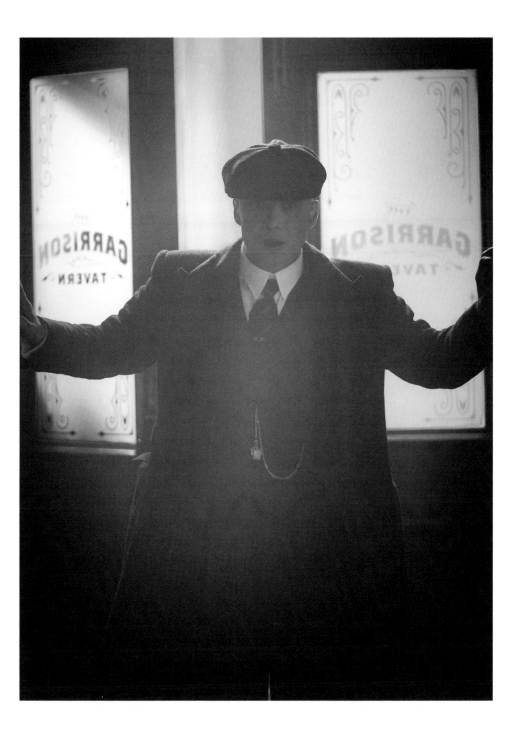

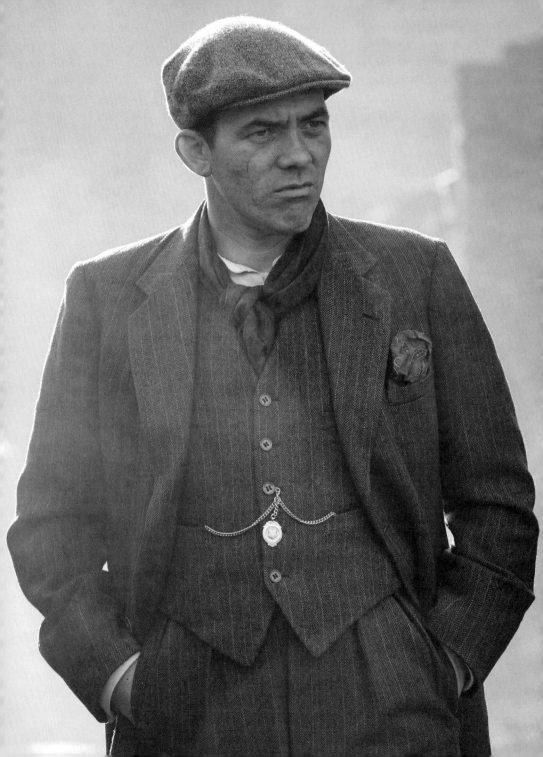

"I don't need good men, Johnny.
For this I need bad men." — Thomas Shelby

"Tommy, his people are fucking savages!
You know, heathens, Tom." — Johnny Dogs

"When you're dealing with a very powerful enemy, taking revenge sometimes requires time. You have to…pick your moment."

— Thomas Shelby

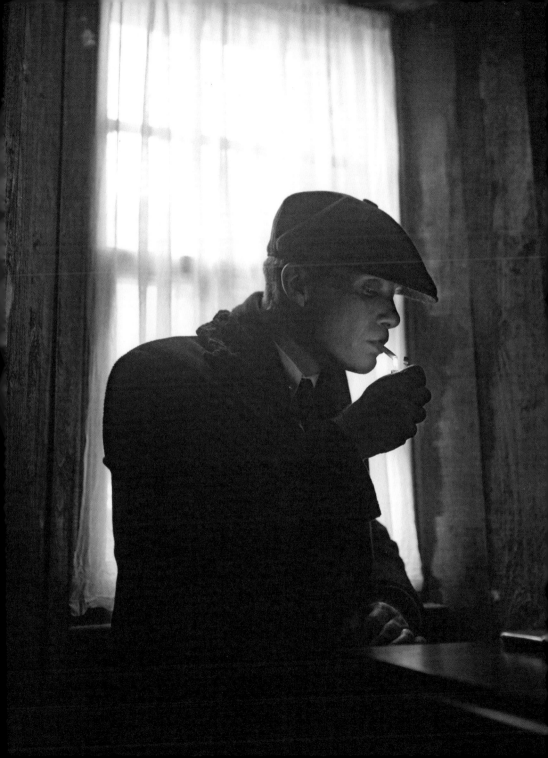

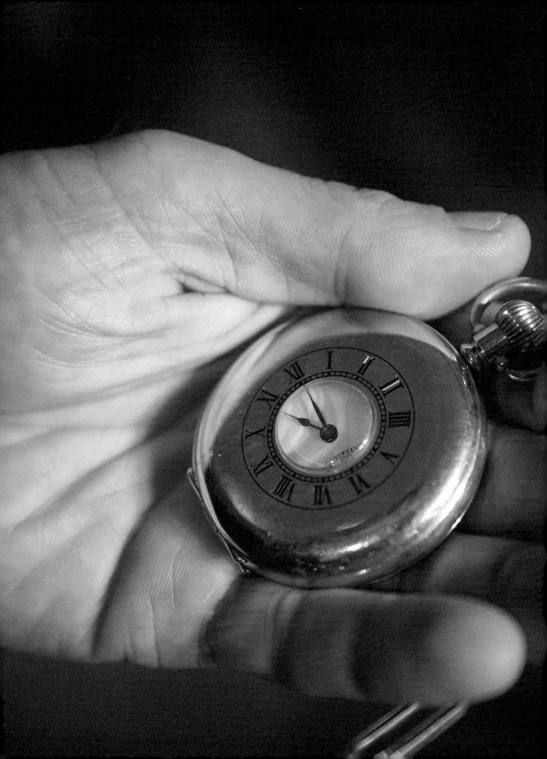

"You are a Shelby.
It says it here on the
back of your watch.
This means you own the watch,
the watch doesn't own you.
The clock strikes six when
you fucking tell it to."

— Thomas Shelby

"This glass.
The bubbles.
They rise to the top.
Each bubble has the same
chance to rise."

— Thomas Shelby

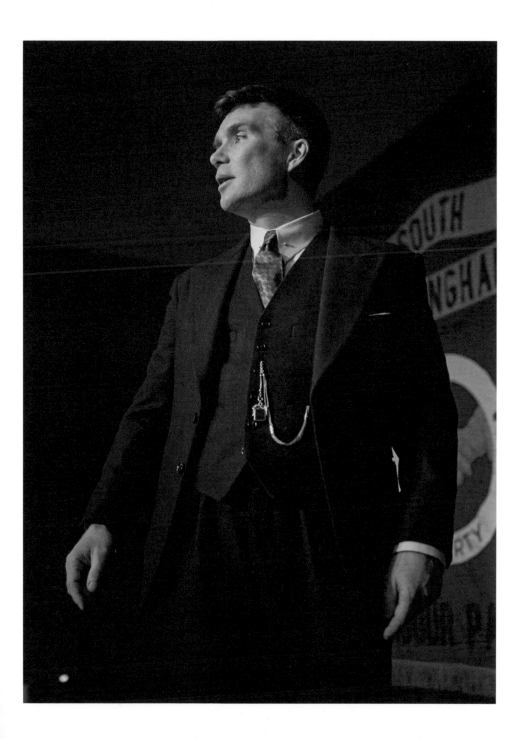

"If you are about to express profound emotion, you might be better served expressing it to someone who gives a fuck.

Or perhaps to somebody who is being paid to pretend to have to."

— Alfie Solomons

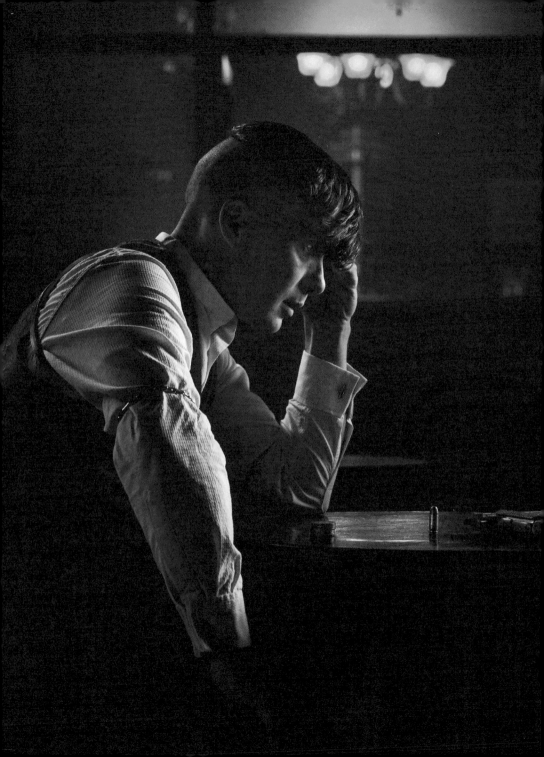

"I am my own revolution."

— Thomas Shelby

"It's not me that's doing the gambling, I'm just taking the bets."

— Linda Shelby

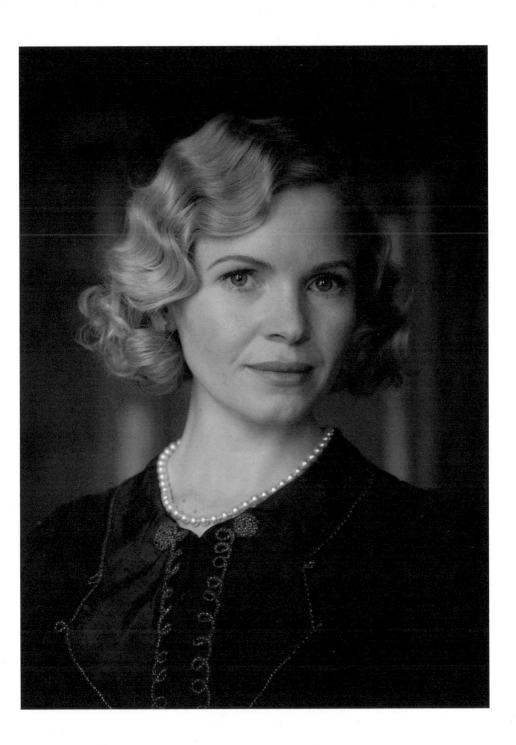

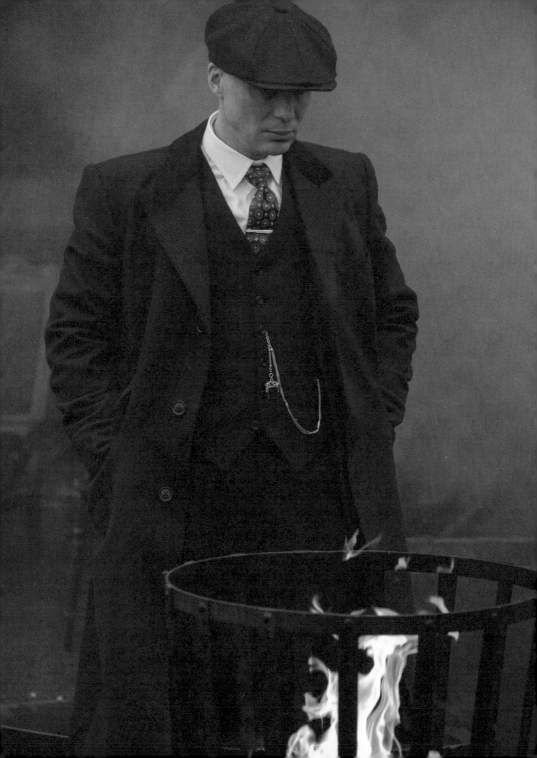

"There is God,
and there are the Peaky Blinders.
This is Sparkhill, we're in Small
Heath. We're much, much closer
at hand than God."

— Thomas Shelby

"Sometimes the women have to take over. Like in the war."

— Polly Gray

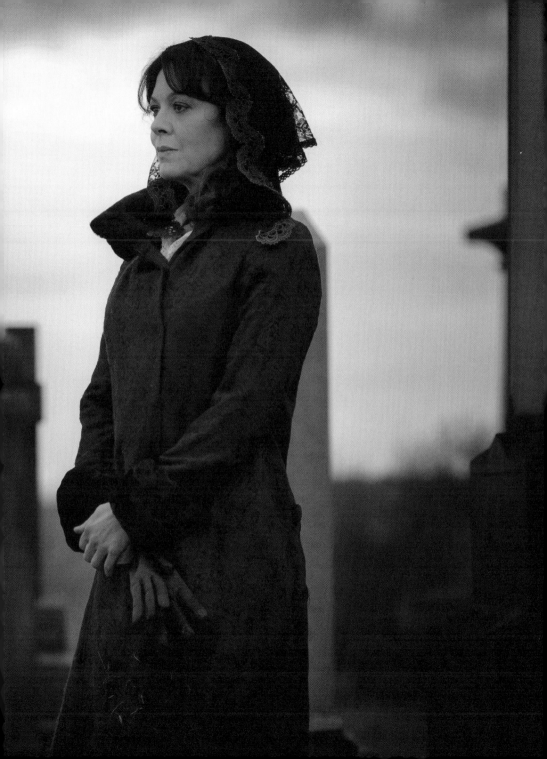

"Chaque catastrophe est
aussi une opportunité."

*"Every catastrophe is
also an opportunity."*

— Thomas Shelby

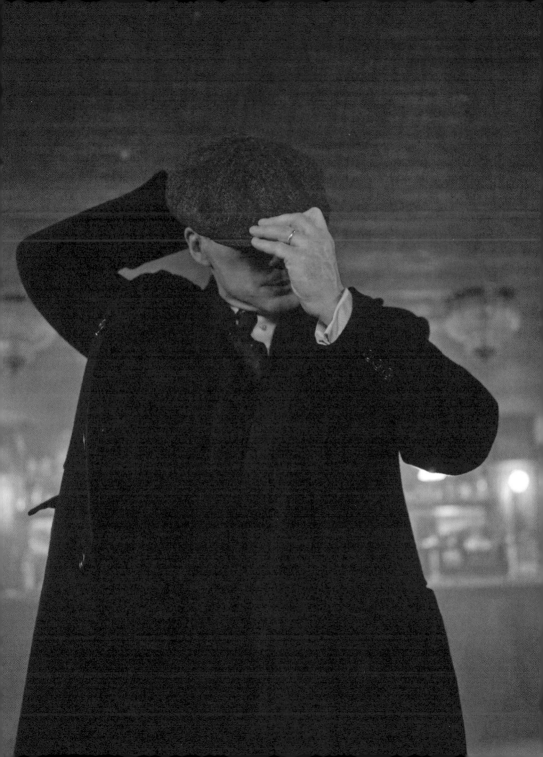

"Welcome to Birmingham!"

— Arthur Shelby

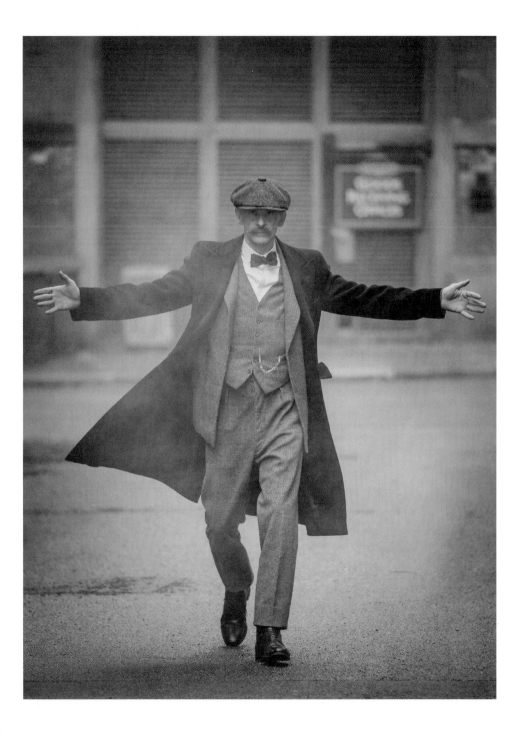

"Do I look like
a man that wants
a simple life?"

— Thomas Shelby

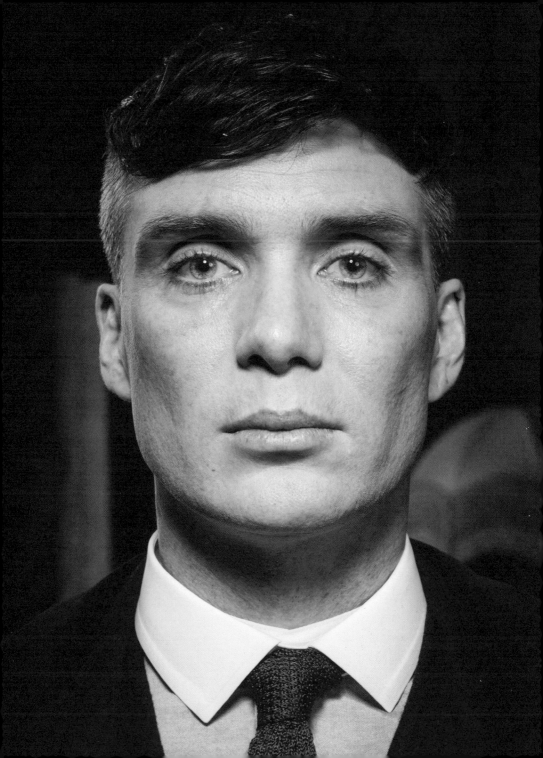

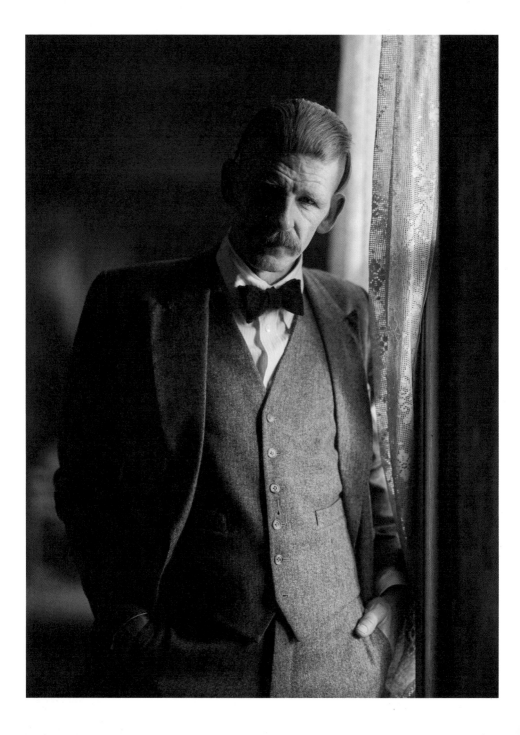

"Ada said it would be OK if I recruited my cousins. Off the streets of Alum Rock and looking for the big time. What do you say, Arthur?" — Isaiah Jesus

"I say big-time boys don't ask for permission." — Arthur Shelby

"He who fights by the sword –
he fucking dies by it, Tommy."

— Alfie Solomons

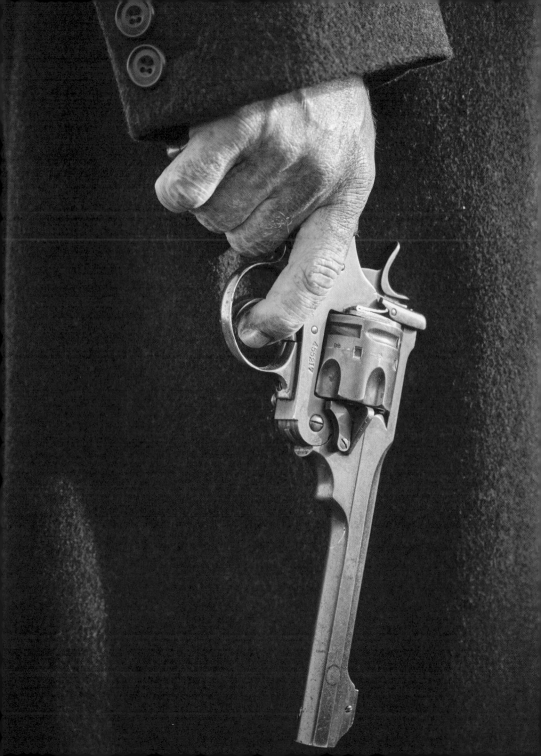

"Nothing here is
stolen…Charlie
simply finds things
before they are lost."

— Thomas Shelby

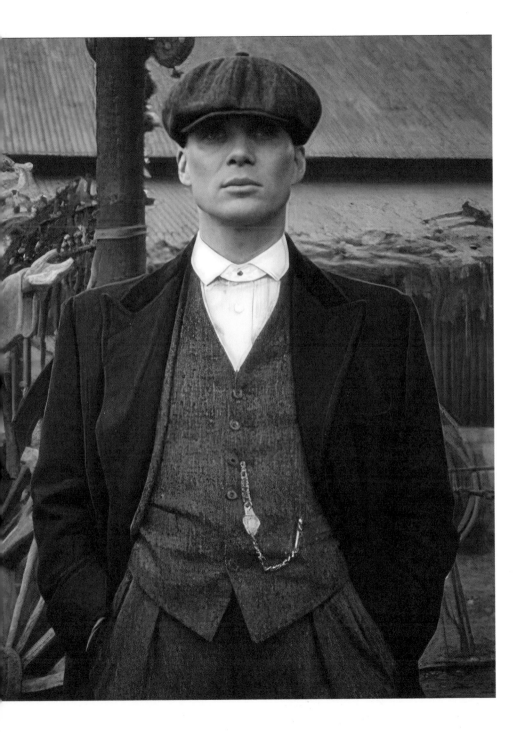

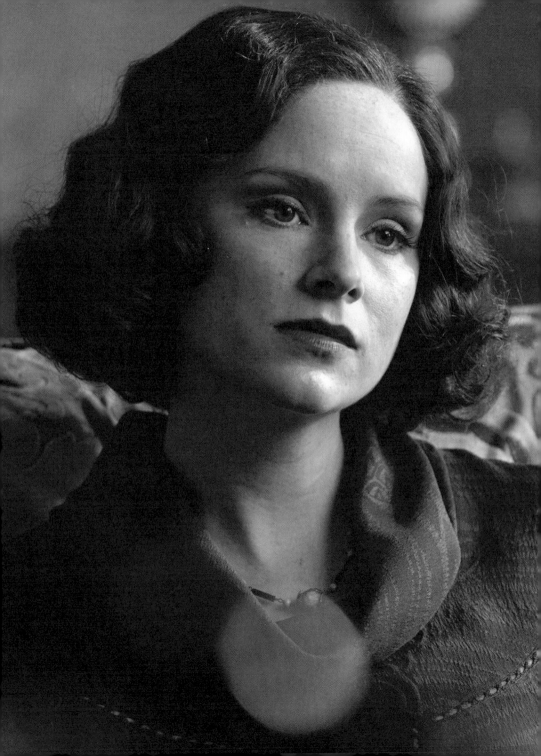

"The name of
the perfume is
'know your fucking
place, soldier'."

— Ada Shelby

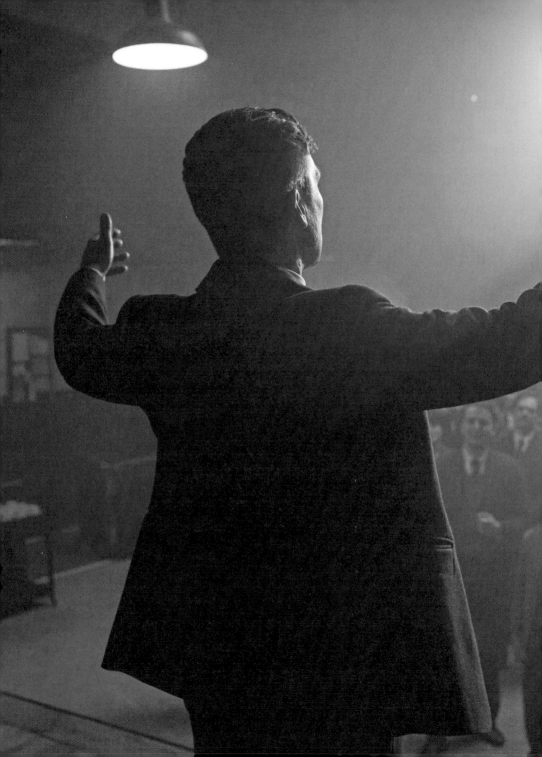

"Since I've entered
politics I've learned that
the line doesn't go out
from the middle to the
left and the right.
It goes in a circle."

— Thomas Shelby

"Men always tell their troubles to a barmaid."

— Grace Burgess

THE

GARRISON

TAVERN

· ESTABLISHED 1919 ·

"You don't get what you deserve, you get what you take."

— Lizzie Shelby

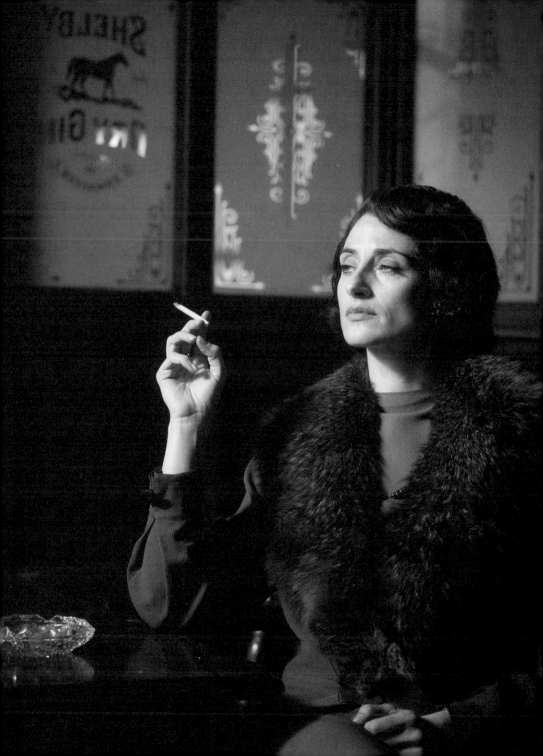

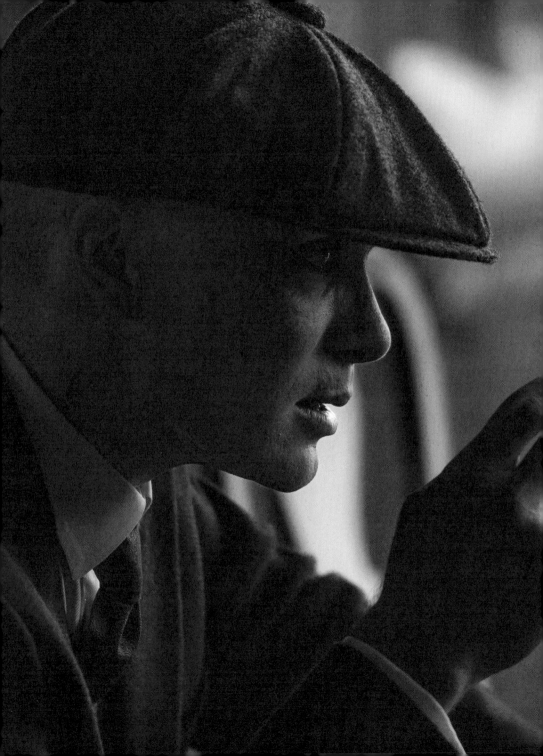

"People are loyal
to those who pay
their wages."

— Thomas Shelby

"Harrods, dope, amphetamines, lords and ladies – you know, the whole English aristocracy thing."

— Jack Nelson

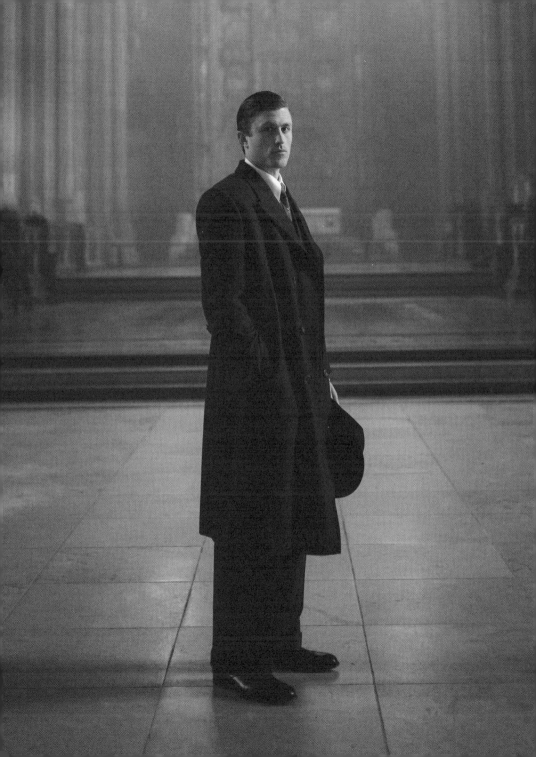

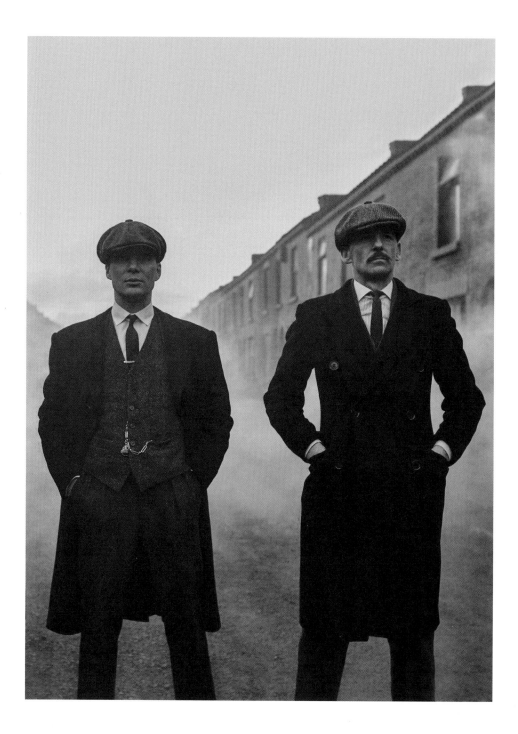

"You do not fuck with the
Peaky fucking Blinders."

— Arthur Shelby

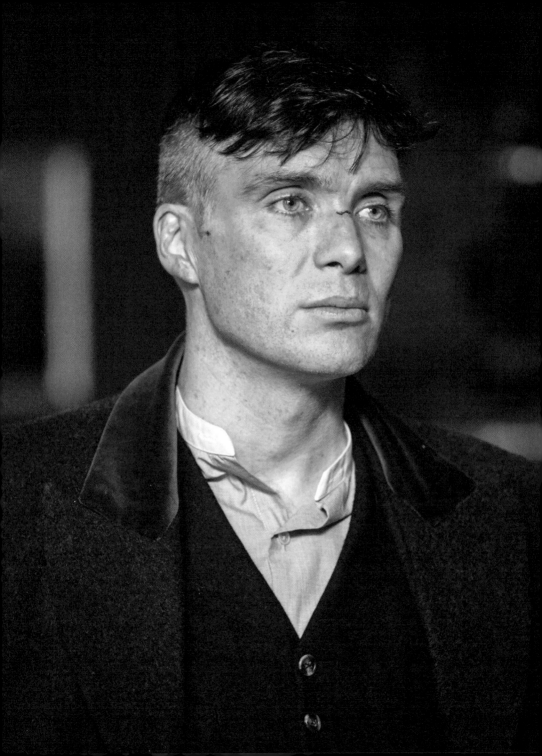

"When you take the King's shilling, the King expects you to kill."

— Thomas Shelby

"What use is a man?
Horse pulls the wagon.
Dog keeps me safe.
Cat keeps me warm at night."

— Esme Shelby

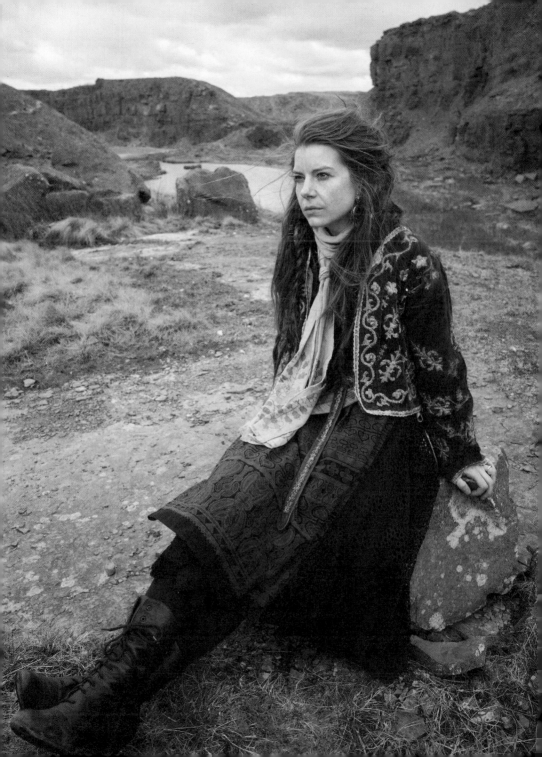

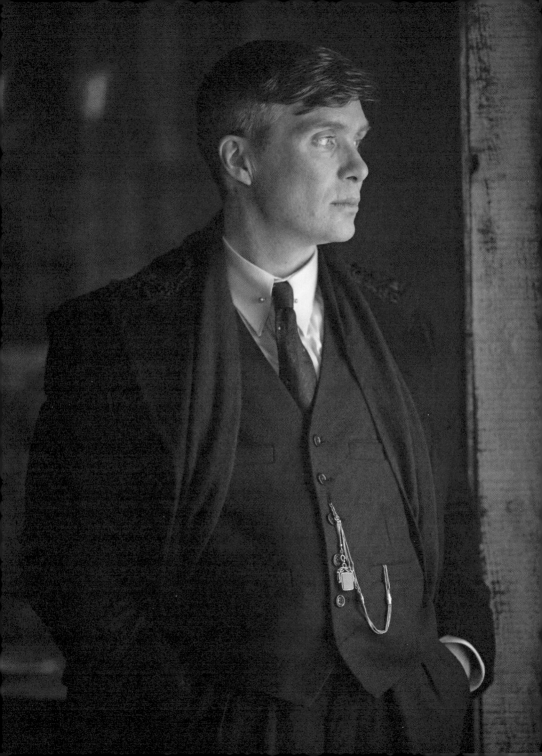

"I learned some things,
such as you strike when
your enemy is weak."

— Thomas Shelby

"Rule one:
You don't punch above your weight!"

— Polly Gray

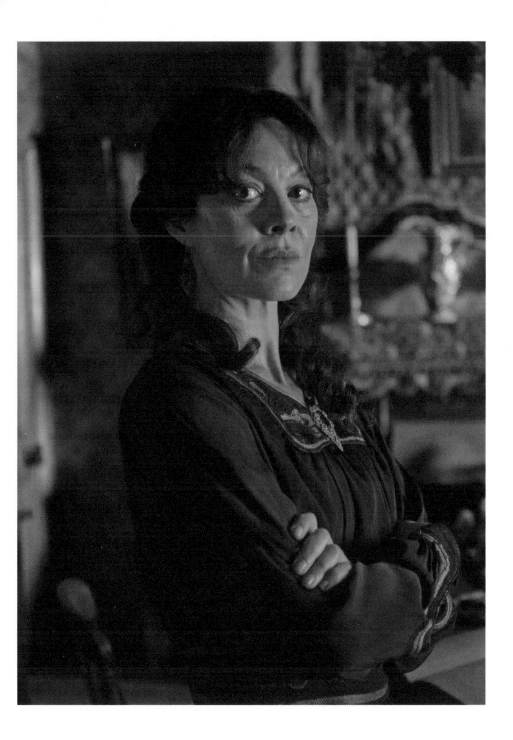

"The only way to guarantee peace is by making the prospect of war seem hopeless."

— Thomas Shelby

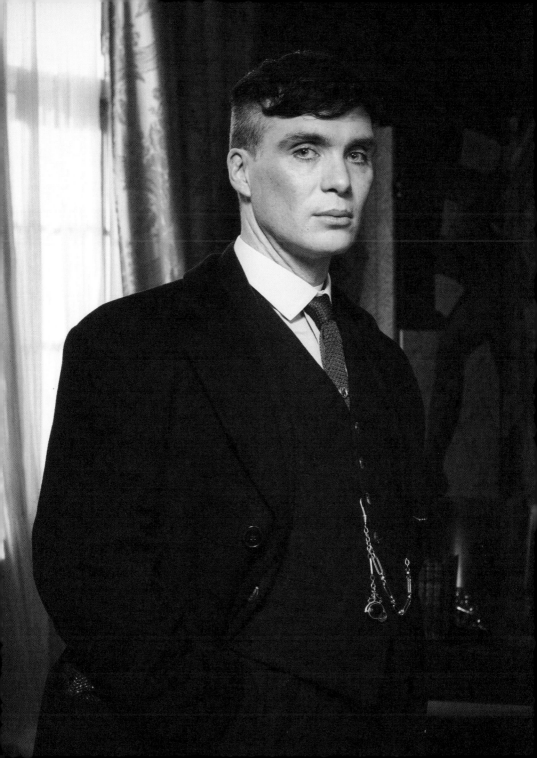

"Remember what
dad used to say:
Fast women and
slow horses will
ruin your life."

— Arthur Shelby

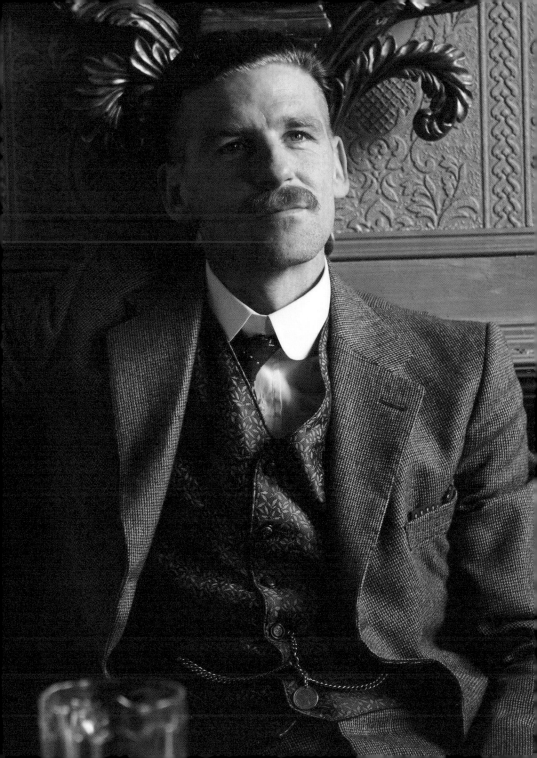

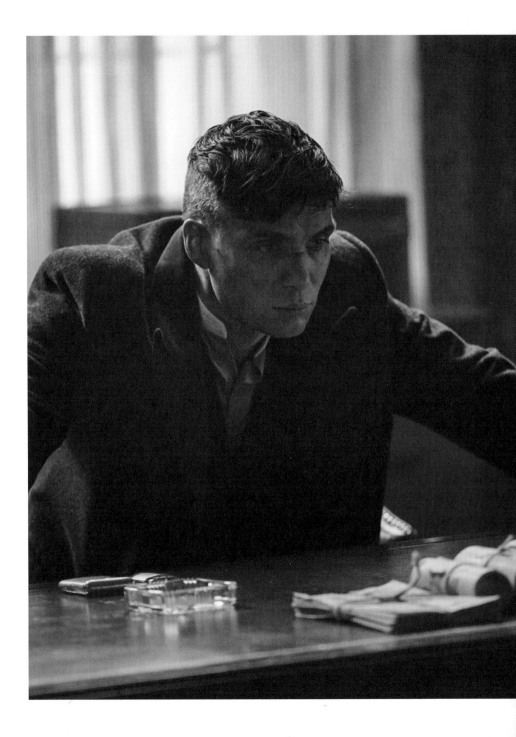

"I've learned something in the last few days. Those bastards. Those bastards are worse than us! Politicians, fucking judges, lords and ladies. They are worse than us. And they will never admit us to their palaces no matter how legitimate we become."

— Thomas Shelby

"It's beautiful.
It was made in Paris." — Ruben Oliver

"It was stolen in Birmingham." — Polly Gray

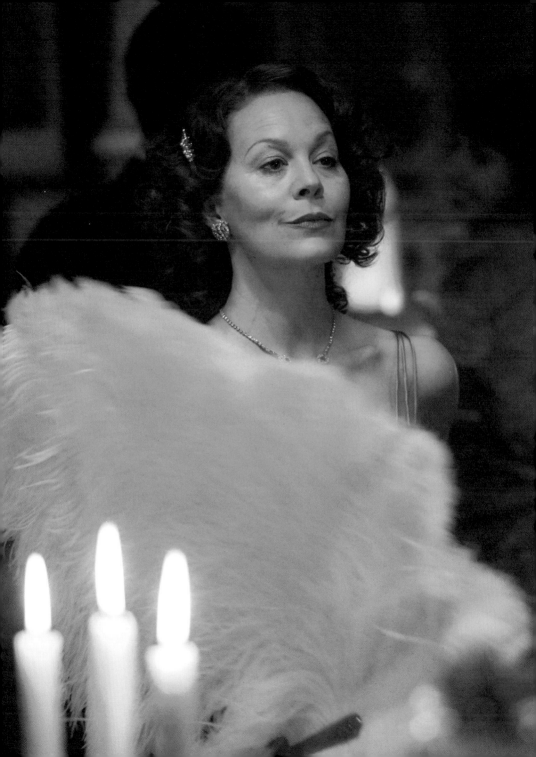

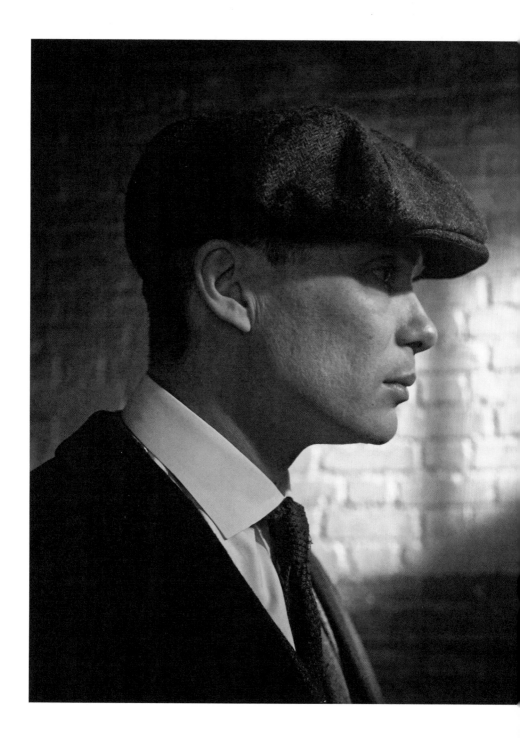

"I can charm dogs.
Gypsy witchcraft.
And those I can't
charm, I can kill
with my own hands."

— Thomas Shelby

"It's much harder to lie with your body than with your words."

— Diana Mitford

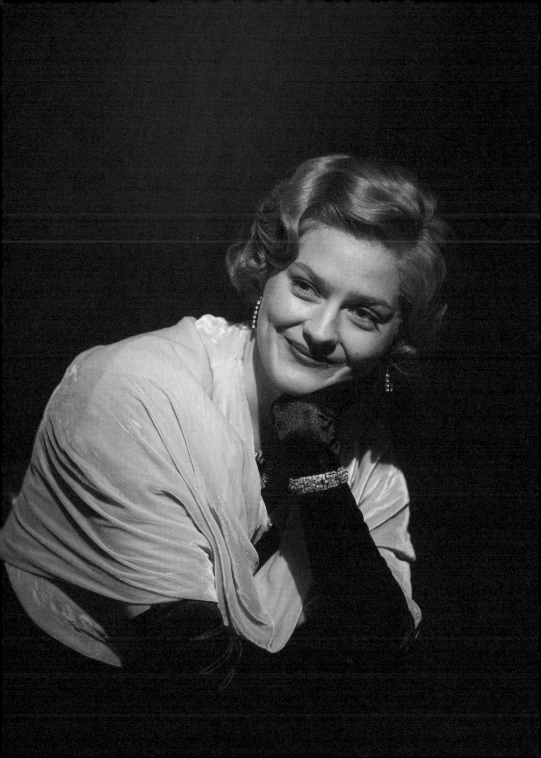

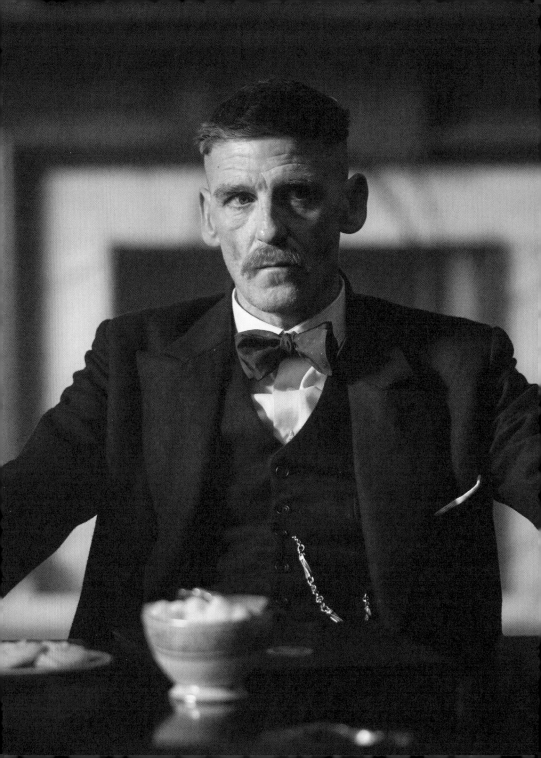

"In the end, it's God who pulls that fucking trigger anyway. We don't get to decide who lives and who dies, Finn. Not us."

— Arthur Shelby

"What's he got, horseshoes in those gloves or what?" — Arthur Shelby

"No, just his dad's strength and his mother's temper." — Aberama Gold

"Everyone's a whore, Grace. We just sell different parts of ourselves."

— Thomas Shelby

"Why should the boys have all the fun?"

— Polly Gray

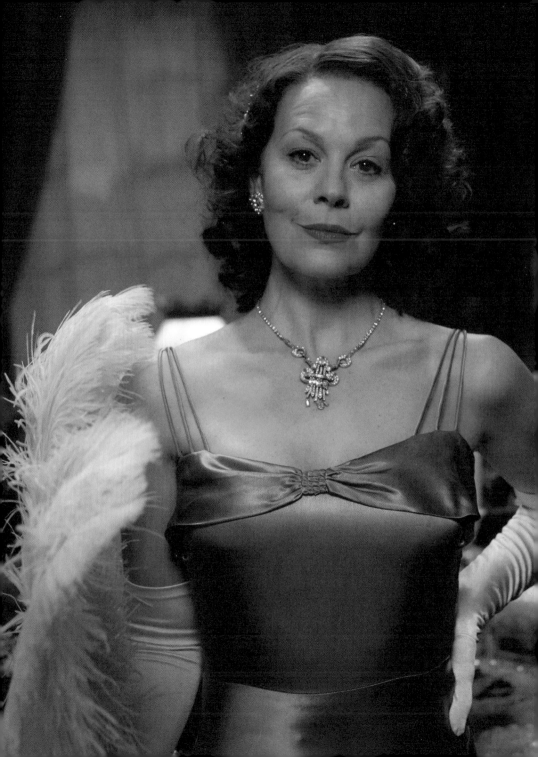

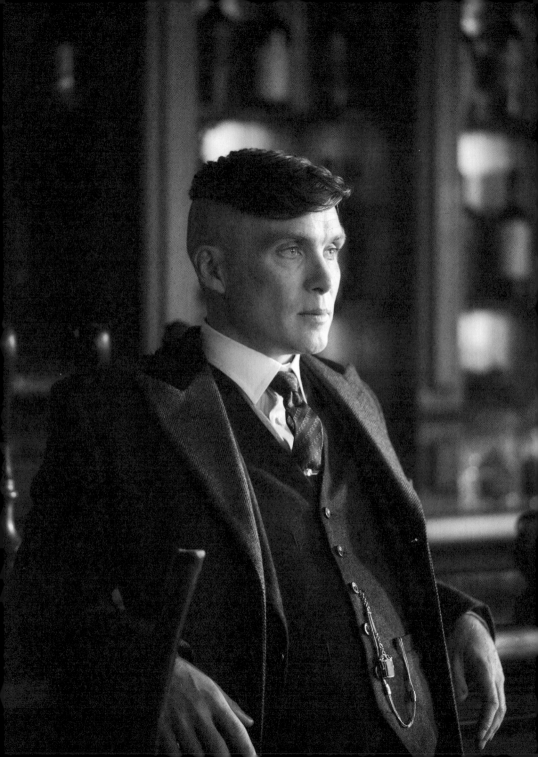

"When you plan something well there's no need to rush."

— Thomas Shelby

"Stay and watch
the fight Alfie?" — Thomas Shelby

"No, you're all right.
I already know who wins." — Alfie Solomons

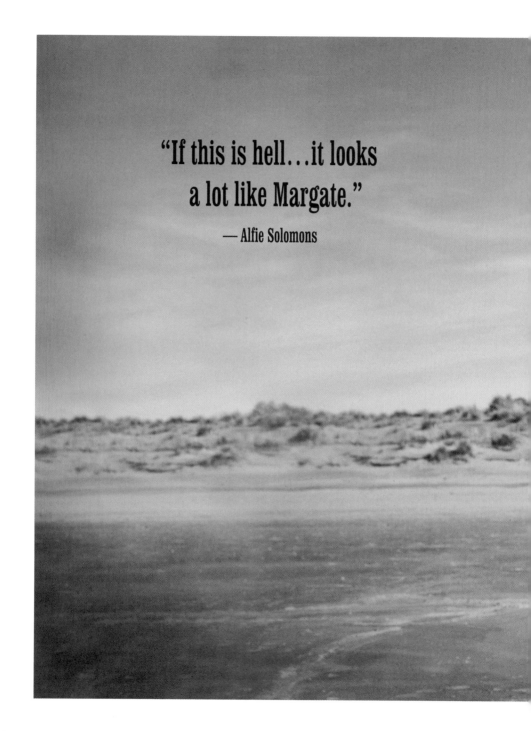

"If this is hell...it looks
a lot like Margate."

— Alfie Solomons

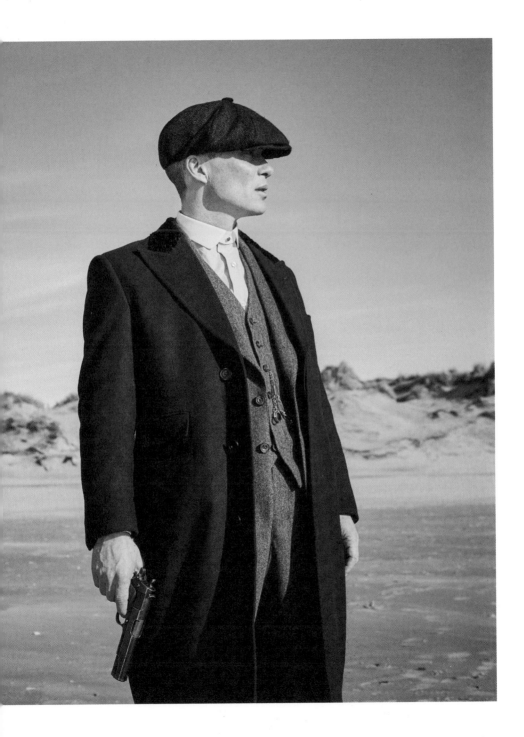

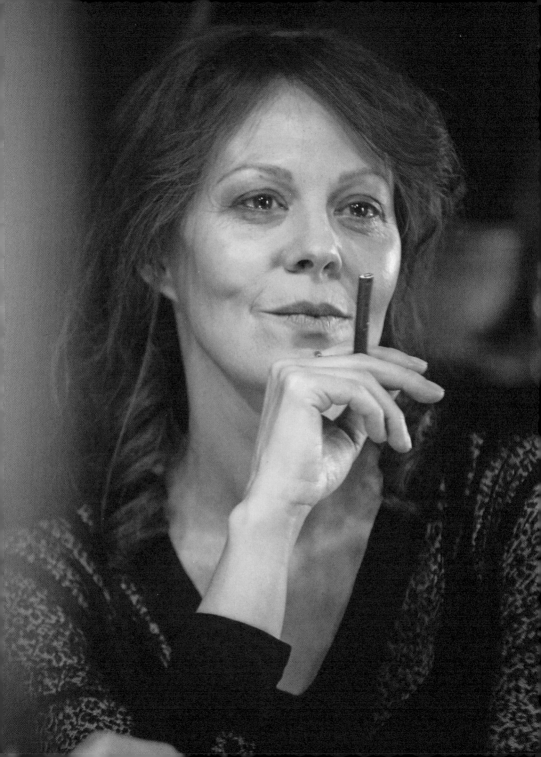

"I put my head in the noose. It's like putting your head through a window and seeing the whole world."

— Polly Gray

"There's no rest for me
in this world.
Perhaps in the next."

— Thomas Shelby

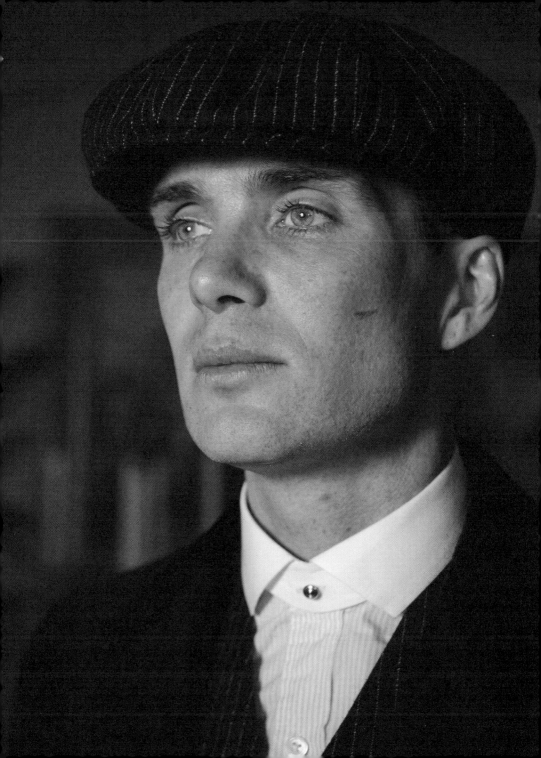

Quarto

Images and quotes from the Peaky Blinders Series © 2013–2023
Caryn Mandabach Productions.
Peaky Blinders™ © 2013–2023 Caryn Mandabach Productions Ltd.
Licensed by Banijay Group. Peaky Blinders is a registered trademark of
Caryn Mandabach Productions Ltd. Licensed by Banijay Brands Limited.

Photography: Robert Viglasky, Ben Blackall, Matt Squire

First published in 2023 by White Lion Publishing
an imprint of The Quarto Group.
1 Triptych Place, 185 Park Street,
London, SE1 9SH, United Kingdom
T (0)20 7700 6700
www.quarto.com

ISBN 978-0-7112-8878-2

10 9 8 7 6 5 4 3 2 1

Printed in China

Design & Editorial by Roland Hall

MIX
Paper | Supporting
responsible forestry
FSC® C016973
www.fsc.org

Productions Ltd.

Banijay